COCA-COLA® DREAMING

TIM McCLAIN

Copyright © 1996 by Tim McClain

Printed in the United States of America
Published by Crane Hill Publishers
2923 Crescent Avenue, Birmingham, Alabama 35209

Library of Congress Cataloging-in-Publication Data

McClain, Tim.
 Coca-Cola dreaming: vintage outdoor advertisements for America's favorite
soft drink / Tim McClain.
 p. cm.
 ISBN 1-881548-91-0
 1. Advertising—Carbonated beverages—United States—Pictorial works.
2. Cola drinks—United States—Pictorial works. 3. Coca-Cola (Registered
trademark)—United States—Pictorial works. I. Title.
HF6161.B3M38 1996
659.1'966362'0973--dc20 95-53873
 CIP

10 9 8 7 6 5 4 3 2 1

SPECIAL THANKS FROM THE AUTHOR TO:

ERIKA CLARK, FOR KEEPING HER EYE OUT FOR SIGNS
WHILE I KEPT MY EYE ON THE ROAD;

CORY MCBURNETT, FOR MAKING THE ORIGINAL PRINTS
FOR THIS BOOK;

MELANIE HILL, FOR GATHERING THE BACKGROUND
INFORMATION ON THE COCA-COLA COMPANY;

JACK ASHMORE, FOR SHARING HIS STORIES ABOUT
PAINTING COCA-COLA SIGNS;

AND ALL MY FAMILY AND FRIENDS WHO WATCHED FOR
SIGNS AND TOLD ME ABOUT THEM.

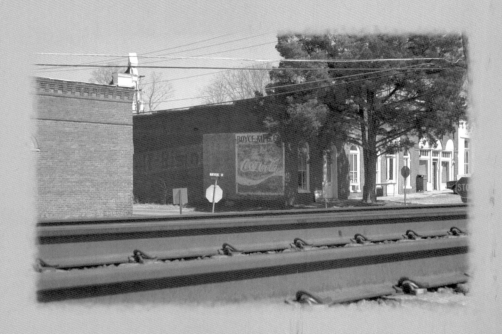

DOWNTOWN ACWORTH
ACWORTH, GEORGIA

INTRODUCTION

It's the real thing, the pause that refreshes, the drink that celebrates the good times of our lives, from childhood soda pop to grown-up rum-flavored libations. It's Coca-Cola, part of the American dream for over a hundred years.

When Atlanta pharmacist John Styth Pemberton concocted a new proprietary medicine in 1885, little did he dream it would one day become the everyday soft drink of choice for millions of people worldwide. Always experimenting with new remedies, Doc Pemberton mixed the extracts of coca leaves and kola nuts with water, sugar, and wine in a three-legged kettle over a fire in his backyard and stirred the bubbling brew with an oar. He named the cooked-down syrup French Wine Cola—Ideal Nerve and Tonic Stimulant and marketed it as a cure for hangovers and headaches.

Playing off the words "coca" and "cola," Frank Robinson, one of Pemberton's business partners, suggested calling the syrup Coca-Cola and writing the logo in the then-popular Spencerian script. Robinson thought the two flowing-script Cs would look good in advertisements—and how right he was! Although the closely guarded secret Coca-Cola formula is not the same as Pemberton's original recipe, the now-classic logo has remained the same for 111 years.

Coca-Cola's first customers paid pharmacists 5 cents for a tablespoon of syrup mixed with water. Coke, as it quickly became known, enjoyed instant success as the latest fad medicine. When one pharmacist accidentally mixed the syrup with carbonated water, Coke became the even more popular soft drink.

Served in specially designed shapely glasses at drugstore soda fountains and later in recognizable-by-feel glass bottles, Coca-Cola grew in popularity and profits beyond anyone's wildest dreams. One enthusiast proclaimed it to be "the holy water of the South." Legions of Atlanta businessmen, starting with the enterprising Asa Candler, who acquired sole control of the business in 1891, became millionaires from Coca-Cola stock. William Allen White, the famous Kansas newspaper editor, wrote that Coca-Cola was the "sublimated essence of all that America stands for. A decent thing, honestly made, [and] universally distributed."

Carefully designed, upscale advertising hyped Coke's universal appeal. It became the anytime, anywhere, feel-good soft drink that invited relaxation and daydreaming. Attractive, successful-looking people appeared in wish-you-were-here places doing fun things and, naturally, drinking Coca-Cola. Well-dressed businessmen, fashionably attired women shoppers, Norman Rockwell's freckle-faced children, movie stars, and Santa Claus smiled and drank Coke. "My hat's off to the Pause that Refreshes," announced Santa in 1931, and artist Haddon Sundblom's jolly, red-clad elf has starred in Christmas fantasies ever since.

Streetcar signs, serving trays, posters, billboards, calendars, clocks, pencils, and even walls carried Coke's upbeat message. In 1894 in Cartersville, Georgia, a sign painter dipped his brush into the trademark red and painstakingly applied it to the side of a building. By 1914 hand-painted Coke ads enlivened more than five million square feet of walls across America. A Coke salesman reported that one consumer felt "hounded almost to a state of imbecility" by all the Coca-Cola signs he saw. The poor man dreamed big white devils with red cloaks were chasing him screeching, "Coca-Cola! Coca-Cola!" He finally decided he would drink Coca-Cola so he wouldn't lose his sanity.

Who doesn't remember riding in the family car and passing those ubiquitous hand-painted Coca-Cola signs? Atlanta photographer Tim McClain certainly does. Noticing that many of the signs were fading away from old age or disappearing as buildings were torn down to make room for new ones, Tim decided to capture the signs he could find on film and preserve the memories for all of us. So relax with *Coca-Cola Dreaming* and enjoy the pause that refreshes.

VIII

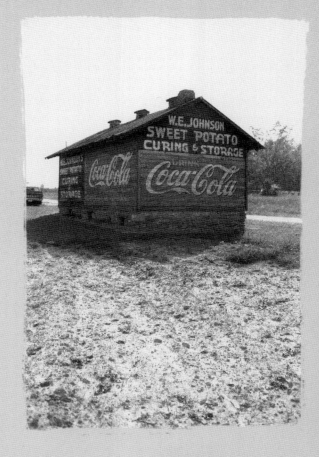

HIGHWAY 27 AND
MASHBURN ROAD
NEAR
CARROLLTON,
GEORGIA

JACK ASHMORE

When Jack Ashmore was a youngster, he stood up a geography book on his school desk so his teacher wouldn't see him drawing on his sketch pad. When Jack was a young man, he stood up on a ladder and painted Coca-Cola signs on buildings for all the world to see.

Jack doesn't remember how many Coca-Cola signs he painted in Georgia and Alabama during the 1930s—he just knows it was "a lot." Coca-Cola would give him a detailed sketch, and Jack drew the words and images freehand, being very careful to match the company's sketch down to the smallest detail. Jack and his partner

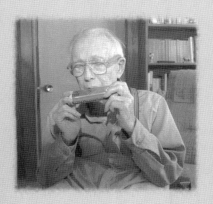

spent one to two days on each new painting. Sometimes the profit was only a dollar (fifty cents for each of them), but Coca-Cola also paid for their dinner and, of course, all the Coke they could drink.

Jack still loves to paint, and he also enjoys playing his harp (harmonica). Jack now lives in Carrollton, Georgia, where he's loved and respected as an artist and musician.

COCA-COLA® DREAMING

TIM McCLAIN

2

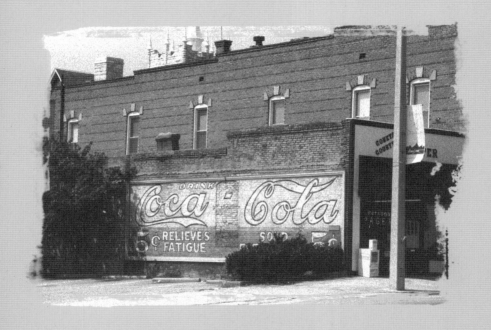

LaGrange Street
Newnan, Georgia

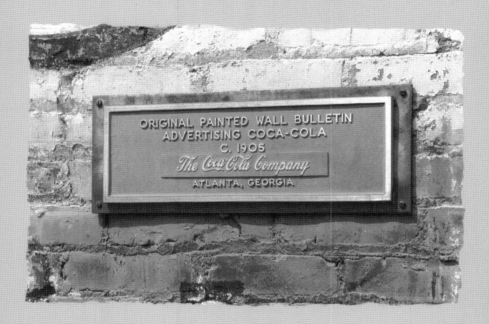

3

THIS PLAQUE DESIGNATES THE SIGN ON
THE FACING PAGE AS ONE OF THE OLDEST
REMAINING HAND-PAINTED COCA-COLA
OUTDOOR ADVERTISEMENTS.

4

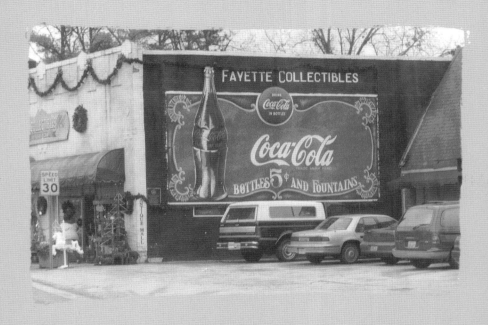

HIGHWAY 54 AND GLENN STREET
FAYETTEVILLE, GEORGIA

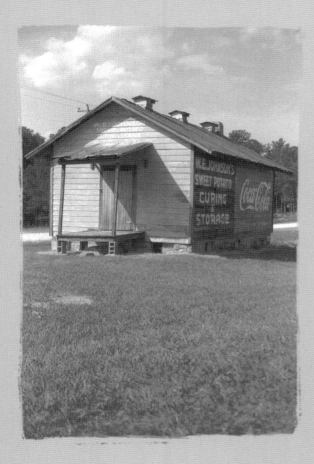

5

HIGHWAY 27
AND MASHBURN
ROAD
NEAR
CARROLLTON,
GEORGIA

6

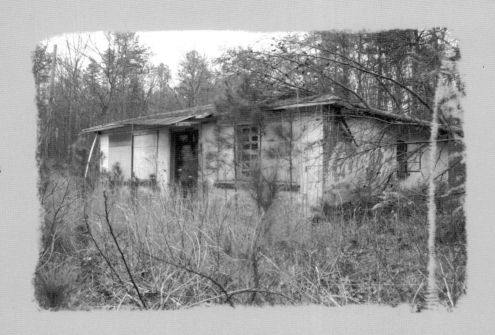

HIGHWAY 27 ALTERNATE
NEAR CARROLLTON, GEORGIA

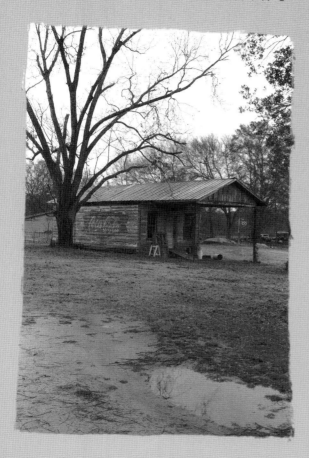

RIGGINS
FERRY ROAD
NEAR
WOODBURY,
GEORGIA

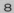

LaGrange Street
Grantville, Georgia

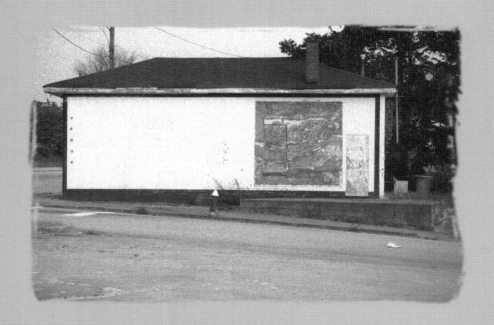

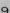

9

WESTVIEW AND MONTGOMERY STREETS
VILLA RICA, GEORGIA

10

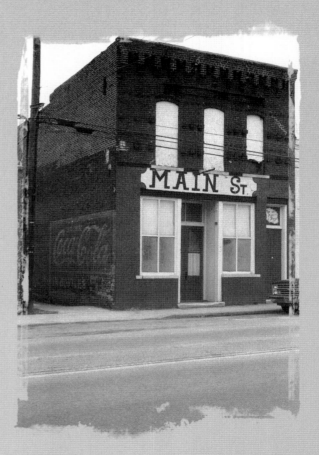

HIGHWAY 31A
CORNERSVILLE,
TENNESSEE

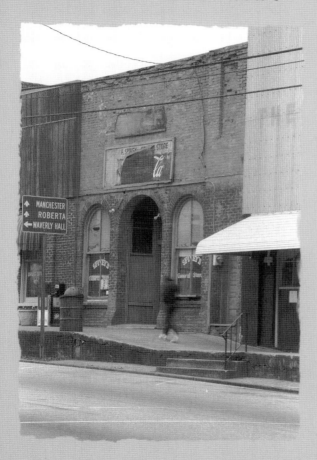

WASHINGTON
AVENUE
TALBOTTON,
GEORGIA

12

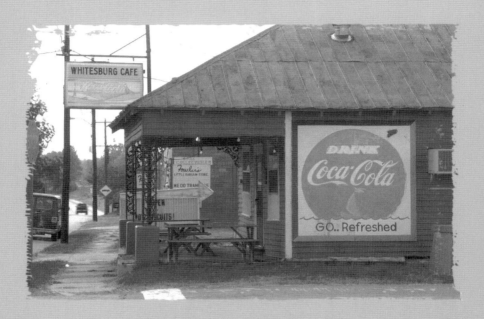

HIGHWAY 27 ALTERNATE AND MCINTOSH STREET
WHITESBURG, GEORGIA

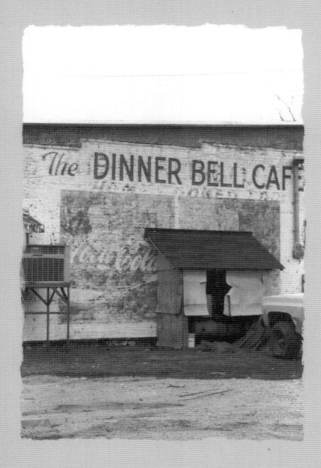

13

HIGHWAY 27
LYERLY,
GEORGIA

14

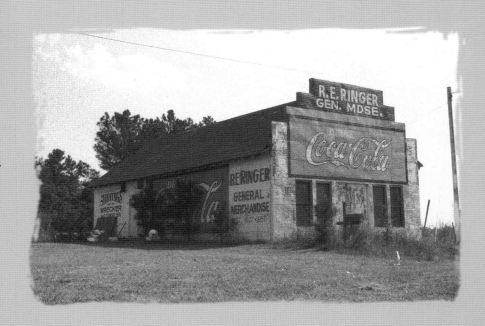

HIGHWAY 27
CARROLLTON, GEORGIA

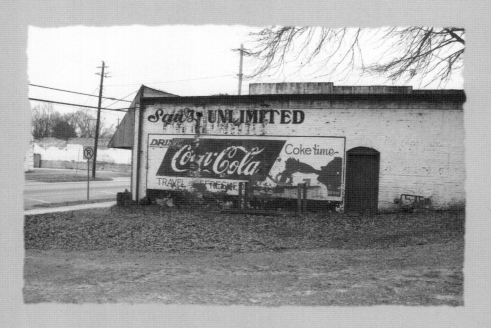

15

16

Highway 27
Roopville,
Georgia

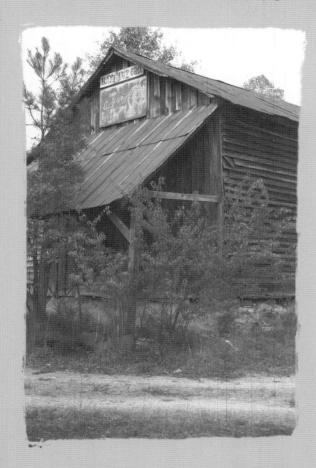

17

BANNING
MILL ROAD
WHITESBURG,
GEORGIA

18

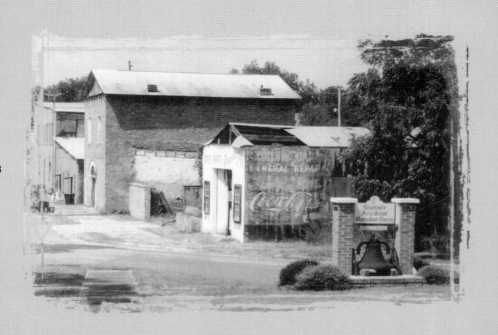

CHURCH AND LONE OAK STREETS
GRANTVILLE, GEORGIA

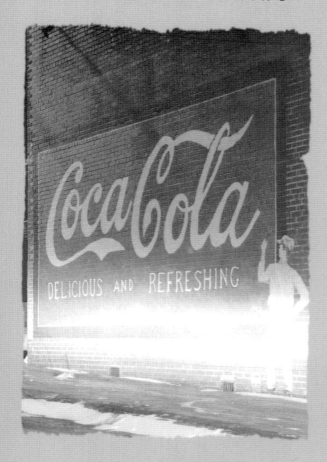

19

OLD TOE RIVER
ROAD AND
HIGHWAY 194 N

NEWLAND,
NORTH CAROLINA

20

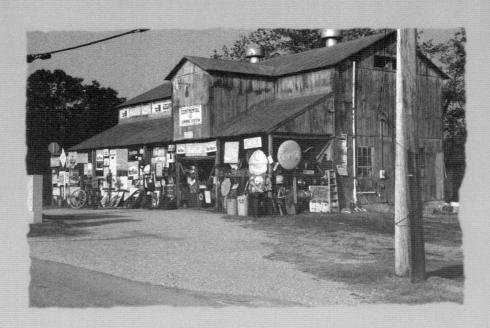

HIGHWAY 27 ALTERNATE AND HENRY BRYANT ROAD
SERGEANT, GEORGIA

CARROLLTON
SQUARE

CARROLLTON,
GEORGIA

22

BARTEE STREET
WOODBURY, GEORGIA

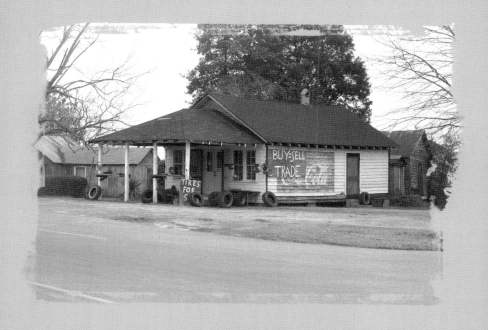

HIGHWAY 113
CARROLLTON, GEORGIA

24

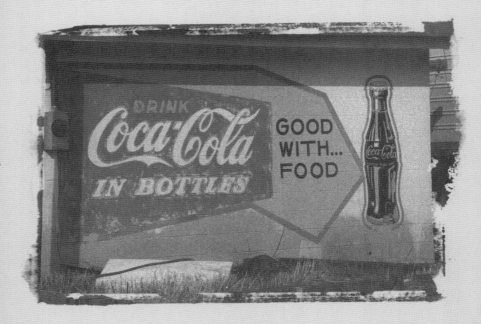

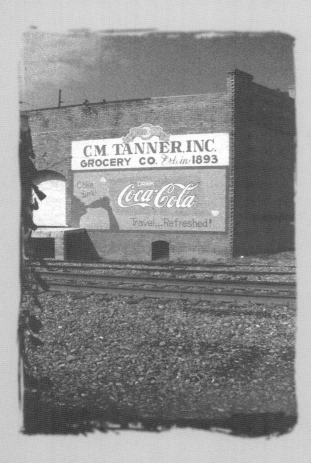

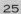

MAPLE STREET
CARROLLTON,
GEORGIA

26

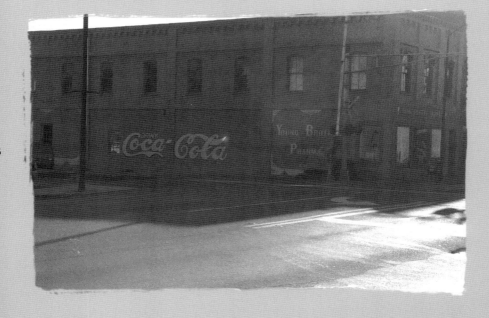

CARTERSVILLE SQUARE
CARTERSVILLE, GEORGIA

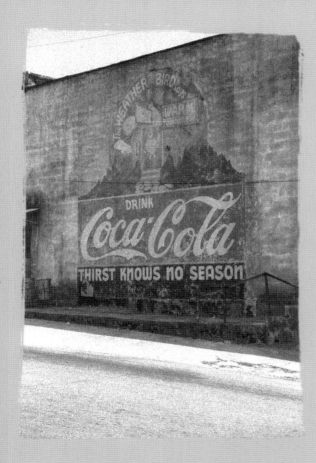

27

MAIN AND
LAGRANGE
STREETS
GRANTVILLE,
GEORGIA

28

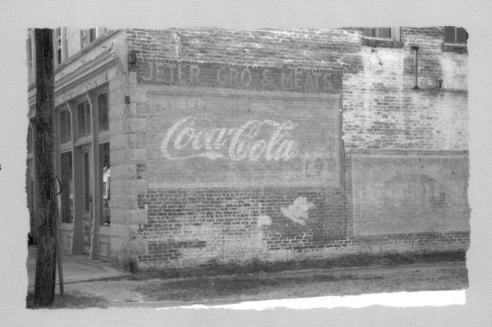

MAIN AND WEST BROAD STREETS
GRANTVILLE, GEORGIA

HASTING BRIDGE
AND TALMADGE
ROADS
HAMPTON,
GEORGIA

30

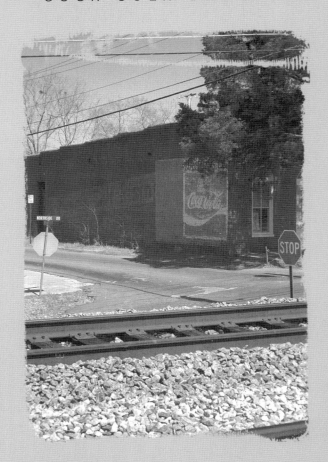

DOWNTOWN
ACWORTH
ACWORTH,
GEORGIA

31

CARROLLTON SQUARE
CARROLLTON, GEORGIA

32

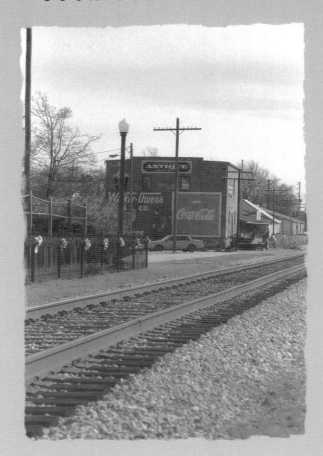

RAILROAD
STREET
JUNCTION
OLD TOWN
CONYERS,
GEORGIA

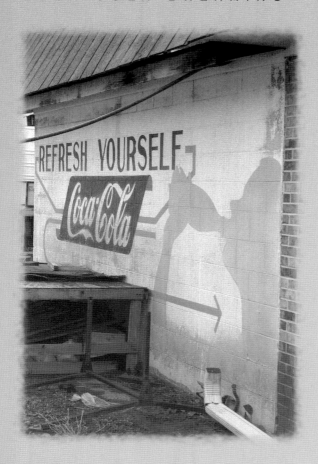

33

HIGHWAY 27
NEAR BOWDON,
GEORGIA

34

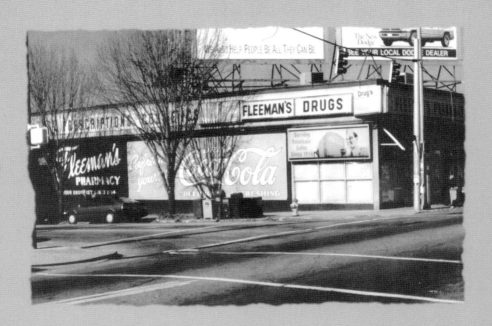

HIGHLAND DRIVE
ATLANTA, GEORGIA

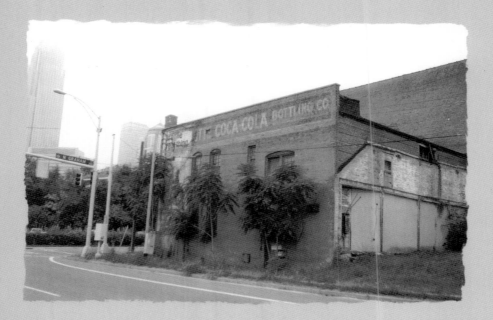

NORTH GRAHAM AND WEST SIXTH STREETS
CHARLOTTE, NORTH CAROLINA

36

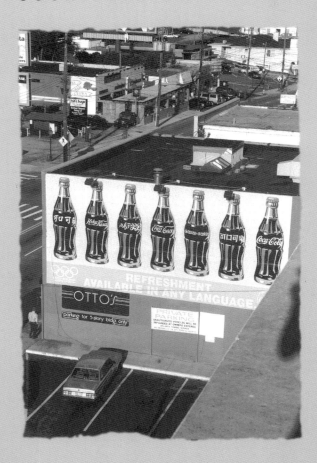

BUCKHEAD
ATLANTA,
GEORGIA

T I M M C C L A I N

The bright colors in the Coca-Cola outdoor signs caught Tim McClain's eye when he was growing up in Georgia. Later, when he became a fashion photographer, Tim starting using the vintage signs on city buildings and country stores as backdrops for his location shots.

Noticing that many of these wonderful signs were fading away from old age or disappearing altogether as buildings were torn down for new construction, Tim decided to photograph as many as he could find. He knows that most of them won't be around much longer.

In 1995 Tim drove down many of the old highways in Georgia, Tennessee, and North Carolina searching out hand-painted Coca-Cola advertisements. He especially enjoyed discovering barely readable logos on tumble-down buildings in almost forgotten crossroad towns.

Tim lives and works in the Atlanta area, and he's still on the lookout for vintage Coca-Cola signs.